Tales of the Forest

Written and Illustrated by

Amy Johnson

authorHOUSE®

AuthorHouse™ UK Ltd.
500 Avebury Boulevard
Central Milton Keynes, MK9 2BE
www.authorhouse.co.uk
Phone: 08001974150

First published by AuthorHouse 11/11/2011

ISBN: 978-1-4670-1976-7 (sc)
ISBN: 978-1-4670-1977-4 (e)

CONTENTS

CHAPTER ONE

Disaster in the Forest

Disaster in the Forest

"Jasper, wake up! -- Jasper!" Old Jasper Prickles was happily snoring, and no doubt dreaming of the sweet strawberries he had brought home this morning, to the great delight of Jessica, his wife. But Jessica had forgotten all about the luscious fruit whose fragrance filled the room. She had been woken by a terrible noise, which sounded very close. She was frightened -- and shook Jasper, begging him to wake, but to no avail. Finally, she curled her spiny hedgehog back and jabbed him with her spikes. That did the trick.

"Why don't you leave me in peace, Jessica? Why don't you let me sleep?" Reproachfully he looked up from his pillow... but then be heard a thunderous crash that shook the whole ground. Now Jasper too was frightened, but for Jessica's sake he put on a brave face. "Oh, it's that noise that scared you! Well, wait here while I have a look and see who is disturbing us."

Before she could stop him, Jasper disappeared through the round doorway of` their little home, and into the undergrowth that covered it. The crashing sounds came from all around now, and Jessica's heart sank with dread, as she worried for Jasper's safety... but even so, she was also just a tiny bit pleased at his bravery.

Old Jasper Prickles was happily snoring

Meanwhile, Jasper was hiding in the grass, trying to make out what was happening. Here outside, all his heroism was gone. Not only could he hear the terrible crashing blows, he could also hear voices. It was those big frightening creatures, the humans! Carefully he climbed an old fallen tree trunk to get a better view, and what he saw made him almost shriek with horror.

The beautiful hollow in the spruce forest had been changed beyond recognition. Tree stumps that provided homes for his neighbours had been smashed to the roots with axes and shovels. The nearest one, standing proud, was their own home... and the house where Jasper had been born. As he took in the scene, his legs began to tremble with anguish, and he quickly jumped back into the grass.

Nearby were standing two of the humans, with spades and pickaxes. One was pointing a finger at the hedgehogs' house, and saying what a hard job it would be to dig it up. Jasper's heart was pounding so hard he could hardly breathe... there was no time to lose! Under cover of the tall grass, he ran back to Jessica as fast as he could.

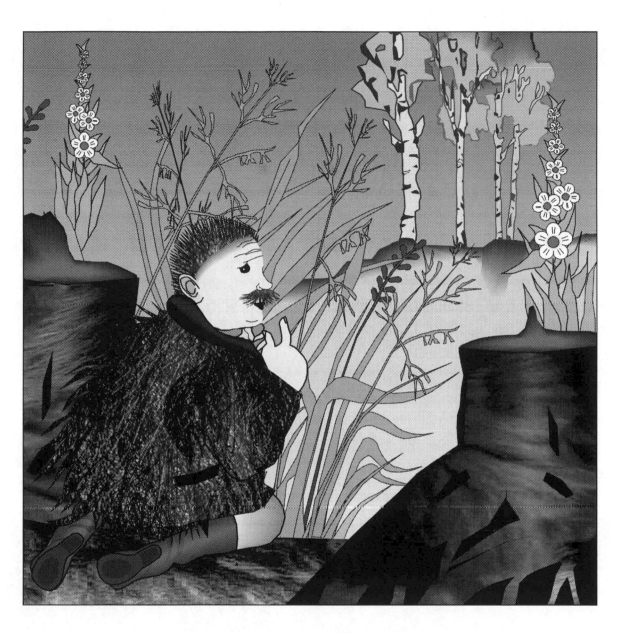

Carefully he climbed an old fallen tree trunk

"Jessica, we must get out of here, quick!" Jasper grabbed her hand and tried to pull her towards the door, but Jessica wriggled out of his grip and started to cry. "We can't go anywhere -- we've got nothing packed... I must make up a bundle to take." But Jasper was very impatient -- "No, Jessica, there's no time for that! Hurry up before it's too late!" Again he grasped her hand and tried to pull her to the door... but the reluctant Jessica stood her ground, sobbing for her bundle.

Then a huge crash shook the whole house to its foundations. Dust and debris showered down on them. Jasper pulled Jessica hard, and they rolled right out of the door. But they did not get any further than that, for right in front of them a man was standing. He noticed them and threw down his axe. Like a bullet, Jasper jumped back into the house, pulling Jessica with him. In the far corner of the room was another door... the two hedgehogs frantically tumbled through it, and ran through the tall grass to the cover of the bushes.

If they could make it to the forest without being spotted, they would be safe. They ran with all their might, not pausing for breath until the first trees of the forest came in sight. "We're nearly there, Jessica", cried Jasper in encouragement. "only a little further and we will be all right".

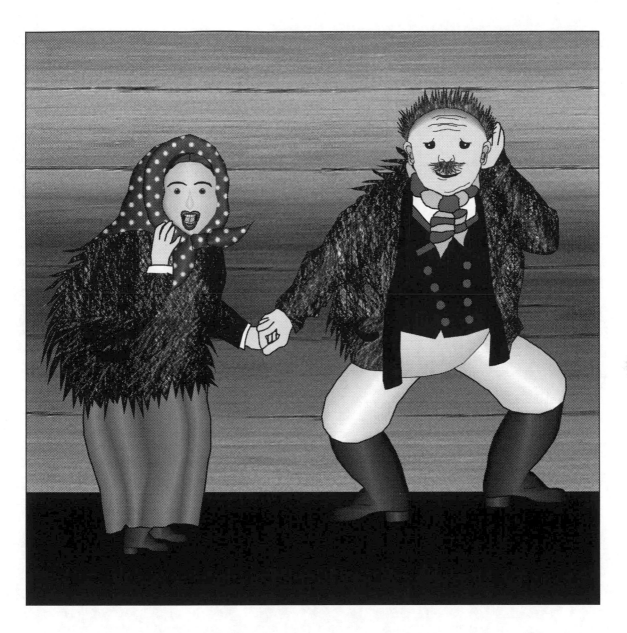

Jasper grabbed her hand and tried to pull her towards the door

But now they came to the edge of the tall grass. They had reached a clearing, which sloped upward between them and the forest. The ground was bare and open, with no cover to hide them. To reach the trees, they would have to cross this. Jasper clutched Jessica's hand tightly and started up the slope... but Jessica could run no more. Faint with exhaustion, she let Jasper pull her forward, almost unconscious.

Somewhere behind them they could hear a shout. This was followed by a tremendous thump, as a huge rock landed right beside them. Jasper was very frightened. He pulled Jessica close up to him, and turned to run to the right, desperately looking for some cover. But there was none to be found, and now they could hear the enemy approaching. Jasper tried to turn around to see what was going on, but just as he was turning his head, something terrible happened — he felt a sudden sharp pain in his shoulder and back. A sickening blow threw him forward, and he lost his hold on Jessica. His eyes went blank — he tried to call to Jessica, but he could not. Then he passed out completely... just in time, he managed to fold his arms and legs, and roll himself into a ball. He seemed to be falling and falling. In fact, he was rolling... he could not remember ever stopping, it seemed like an eternity.

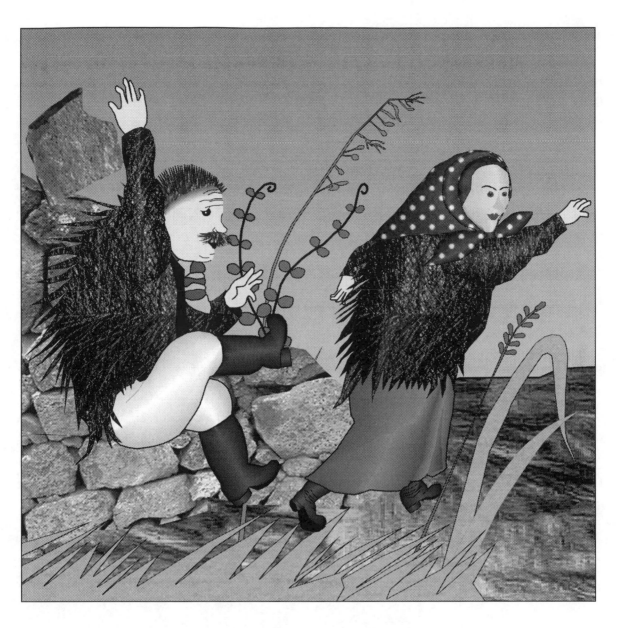

A huge rock landed right beside them

Jessica meanwhile had stumbled into a small hollow covered by a tuft of grass. She might have stayed hidden in this little hole, but the events of the day all proved too much, and she started to sob aloud. This was a bad thing to do -- the man could hear her, and he started to prod the turf where she was hiding, with a stick. She rolled herself into a ball to protect herself, but the stick had a sharp point, which penetrated her prickly coat. She felt a terrible pain, and suddenly found herself pushed out of her hiding place. Fearing this would be the end, she lay motionless, and wondered what fate had befallen Jasper. As she waited, the man seemed to be waiting too. She could see his big boots towering over her. No doubt he was thinking how he could catch the hedgehog without hurting himself on the prickly spines.

Then Jessica noticed that right behind him was an old tree stump. What if she could run between his legs and try to reach it?

Suddenly, the sharp pain struck again, and Jessica hesitated no longer. Desperately she flung herself forward as hard as she could... she ran with all her might between the man's boots, and straight to the tree stump. As she expected, there was a hollow under the trunk and roots... she squeezed herself into it as far as she could, and crouched completely still. The man was amazed. He turned round to the tree stump, and poked at it with his stick, but he could not reach the hedgehog. Eventually, the force of his efforts caused the stick to break, and, with an angry kick at the tree stump, the man gave up his hunt and walked away.

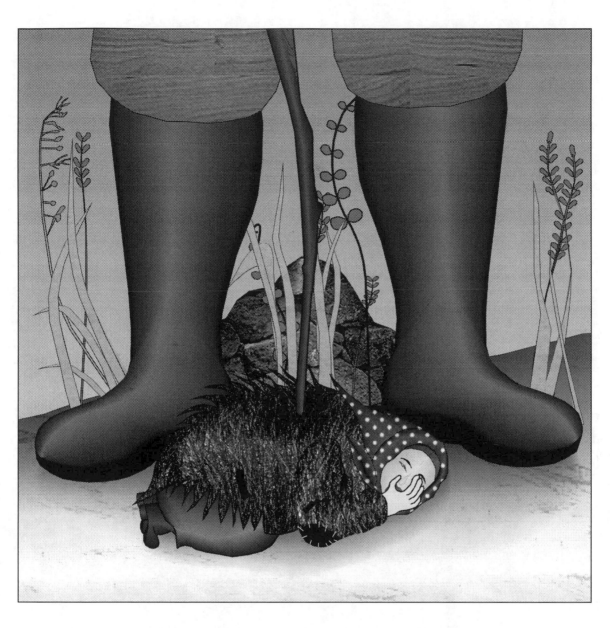

She could see his big boots towering over her

Jessica's whole body ached, but for a very long time she did not dare to move. Then shadows started to descend into the clearing as the sun began to set -- everything was quiet and still. Slowly she stretched herself and silently left her hiding place. The first thing on her mind was Jasper... what has become of him? If he is still alive, he surely could not be far away. She started to call, "Jasper, Jasper, where are you?"... but everything stood still, with not a sound to be heard anywhere. Her heart squirmed with anguish as she ran back to the spot where she last saw him and called out again.

But what is this? Someone is rushing out from the nearby bushes. Why indeed, it was none other than our poor old Jasper...

"Jessica"
"Jasper"

They were hugging and kissing each other, glad to be alive and together again. They sat down in the tall grass and started telling each other everything that had happened since the big rock had parted them. When they had exhausted all the details, Jasper's first thought was to go and see what had happened to their house.

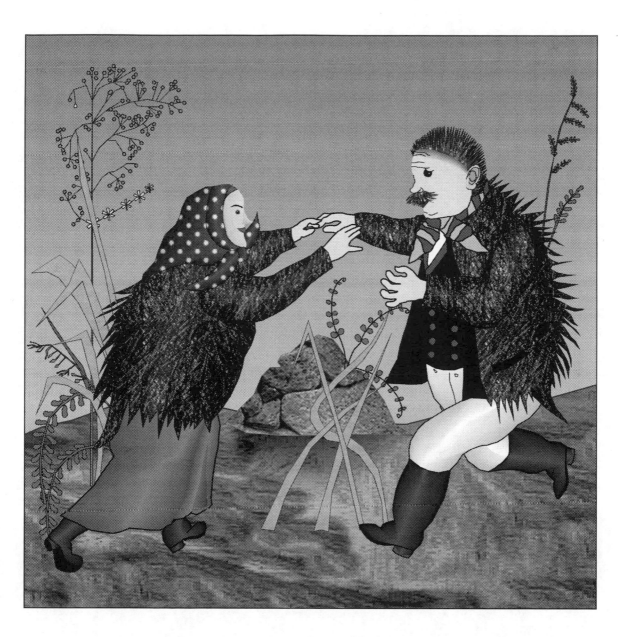

Why indeed, it was none other than our poor old Jasper

Along the way, they could soon see the full extent of the disaster that had struck the countryside. How bare and ugly everything was! The bushes were all torn out... tree stumps lay upside-down, their roots sticking up into the sky... and everything was covered in drying mud that was crumbling into dust.

And when the two hedgehogs finally reached their little house, they cried out with grief. Their cosy household was scattered all around... nothing was left intact. There was no trace of the strawberries that Jasper had gathered. Gone were the little cups made of acorns... gone were the beds with their bedspreads of silky moss. Everything was destroyed, trampled, and smashed to smithereens.

The sun had long since set, but still they stood there silently, sadly staring at the remains of their home. Suddenly Jasper said: "We can't stay here, Jessica. All our neighbours have gone to look for new homes... and so must we. Come, let's go." He wiped his eyes, gently took Jessica by the hand and off they went.

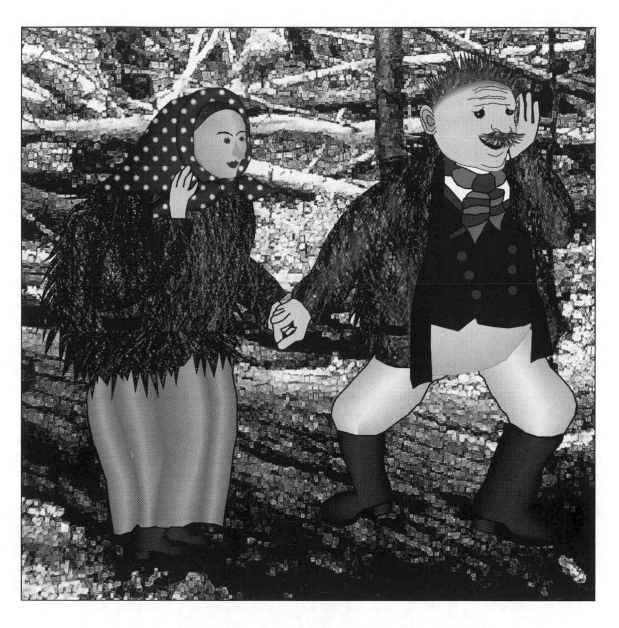

Their cosy household was scattered all around

They ran quickly, ignoring the discomforts of thorns and stones beneath their feet. Jasper's sharp little eyes darted here and there, but nowhere could he see a place as beautiful as the one they had left. On they went, their tiny feet wagging furiously as they trotted. The moon was lighting their way, and when they came to a small clearing in the wood, it shone like a silver lake. They had come far from their home among the spruces.

Suddenly Jessica stumbled on a stone. She was exhausted, and couldn't go any further. Jasper begged her to keep going just a little bit longer. They were nearly at the forest, and they would surely find a new home there.

"No, Jasper... I can't take another step! I have to rest for a bit." And right where they stood, in the middle of the path through the clearing, she sat down. Jasper sat down beside her, but he was all impatient. "I tell you what... you wait here for me, and I'll go and have a look ahead." And without further ado, he was up and gone.

The forest really was quite near. Jasper ran uphill, gently swerving through the dense bushes. And soon his nostrils began to breathe the pleasant smell of the forest, where he was always so happy. "What a beautiful place", he thought to himself... and now his only wish was to find a suitable home for Jessica and himself.

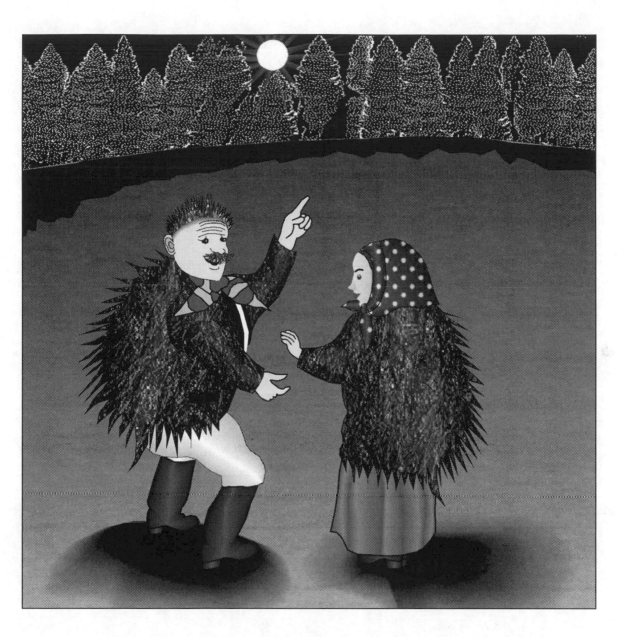

They came to a small clearing in the wood

The moon had risen high, casting streams of shining silver among the trees. Before him lay a small valley, and here Jasper spied a fallen tree trunk. His expert eyes scanned the dense bushes... then he slid down the hillside until he reached a dark hollow beneath the roots of the old tree. And from the moment he saw it, he knew this was the spot.

No-one had taken the place yet, and the whole surroundings appealed to Jasper very much. Immediately he could see where everything would go. He knew at once where the window would be... and here the bed, and there the stove.

Out of sheer happiness, he started to dance. Then he ran out again to look at the house from all sides... and then back inside to march proudly through the spacious room. What a beautiful place it was! Finally, Jasper had fully reassured himself... this would be even lovelier than the home they had left.

And so, happy with his wonderful discovery, he returned to get Jessica... with his hands in his pocket, and whistling a merry tune. At last, they would have their home again.

With his hands in his pocket, and whistling a merry tune

CHAPTER TWO

The New Arrivals

The New Arrivals

Many days had passed since Jasper and Jessica found their new home, and they had been settling in perfectly. A friendly mole, who lived in a nearby field, helped them dig a deep cool cellar underneath the house... and before long the cellar was filled with lots of goodies from the forest. Jessica was looking after the house, cooking, and mending their coats, while Jasper was hunting for food, and building new things for the house. The two hedgehogs lived very happily.

Day followed day, and nothing unusual happened -- until one night. Jasper and Jessica had been building a fence around their new garden. Only the gate was left to do, but it was getting late, and they were both too tired to finish it. So they rolled into their mossy bed and fell asleep immediately. Suddenly, Jasper was woken by a painful scream...

"Are you crying, Jessica?" he asked quietly.
"Yes, it's me Jasper... I've got the most terrible pains!"

Jasper got up instantly to get a wet bandage for her... but during the day, they had used up all their water for watering the garden; there was not a drop left.

The two hedgehogs lived very happily

"Hold on, Jessica, I'll run down to the stream and fetch some." And without even waiting to finish the sentence, he took the bucket and ran.

Through the bushes and the stones he ran, right down the valley and straight towards the stream. The sun had already risen, and Jasper screwed up his eyes in the glare of the bright sunshine. He filled the bucket as fast as he could, and started back for home.

And as he hurried, his coat suddenly touched something soft. He could hear a hissing noise... and in the sunlight, something sparkled. Jasper clutched the bucket and tried to avoid colliding with the unexpected obstacle... but too late! The creature raised its head... and horror! It was a large and venomous snake, whose sunbathing Jasper had accidentally disturbed.

"Please, let me go! I meant no harm", pleaded Jasper, anxious to avoid a fight. "My poor Jessica has a fever, and I must fetch her this water."

"Ssssss--sssss", hissed the snake angrily. "You have pricked me with your ugly coat and torn my lovely dress. I will punish you! Ssss..." The snake's revengeful eyes gazed on Jasper's fear, and her forked tongue prepared to strike a death blow. For Jasper there was no way out. To gain some time, he took the bucket and threw it at the snake... and then rolled himself up into a ball.

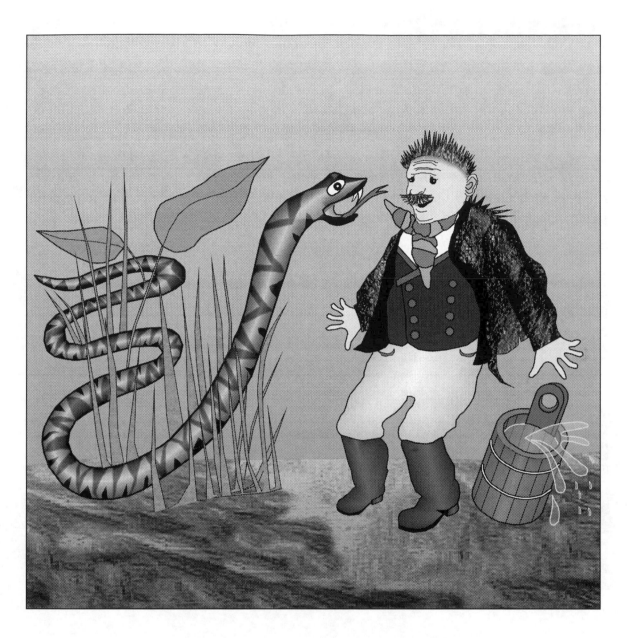

It was a large and venomous snake

The angry snake lunged at him... but she recoiled hissing in pain. Her nose got an unpleasant lesson -- the hedgehog's prickly coat is no joke. She laid her head on the grass and sat motionless watching the dangerous opposition, and waiting to find one small spot for her poisonous fangs.

Jasper knew what she was waiting for, and was very careful. He curled himself up tightly, so not even a sound could penetrate. The birds were singing, the bees were buzzing... and the stream bubbled full of the precious cold water that would make Jessica well again! "I'll look just with one eye, and see what that snake is doing", Jasper said to himself, and started to pull his head out of his fur. But the snake was on guard... and as soon as his small nose appeared, the snake sprang. Jasper surely would be done for! But who would have guessed that his small body was so flexible? At the very moment the snake launched her deadly attack, Jasper somersaulted to escape the blow... and landed with his sharp spiny prickles firmly stuck into the snake's smooth neck.

A terrible fight broke out. "Sss--sss--ssss" hissed the snake angrily, as she squirmed and twisted, vainly trying to bite the hedgehog. And she couldn't squeeze him either, because Jasper's prickles pinned the snake's soft body tight, like needles on a pincushion. The snake tried to shake him off, vigorously tossing every which way... but all to no avail.

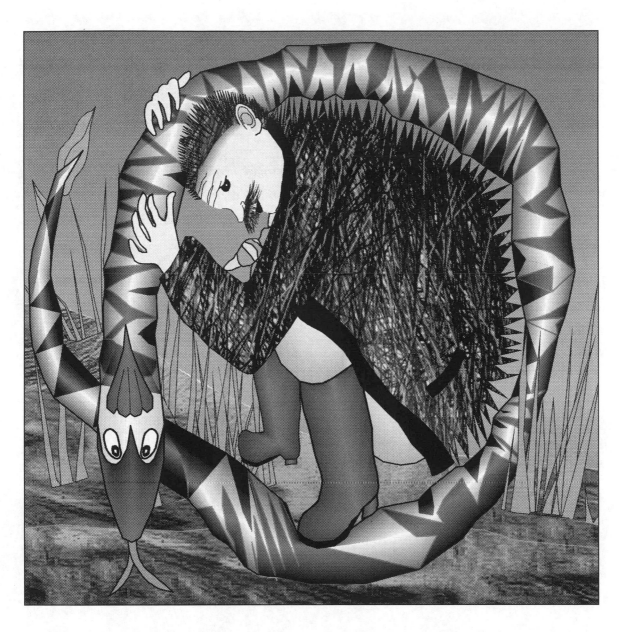

His sharp spiny prickles firmly stuck into the snake's smooth neck

"I don't like to hurt anybody", Jasper said to himself, "but if I let go of this snake, she will surely kill me -- and Jessica will never get her water". So he pressed in his spikes even harder, as hard as he possibly could. Suddenly, all resistance under him was gone... he pressed a little bit harder, and then pulled himself free. The fight was over.

Jasper wiped the sweat from his forehead, took the empty bucket, and hurriedly went to fetch the water again. He forgot all about his deadly encounter, for his thoughts were with Jessica... and as fast as he could, he hurried back home.

His heart was beating like a drum as he approached the house. He opened the door quietly, and held his breath. There, in the mossy bedspread, lay Jessica, with a big beaming smile on her face. And around her -- he couldn't believe his eyes -- were wriggling five tiny baby hedgehogs. And goodness! What beautiful hedgehogs they were! Each one lovelier than the next, and all squirming to snuggle up to their mother.

Jasper stood by the door, with the bucket in his hand, almost choked with emotions. Suddenly, he put the bucket down sharply, spilling the water, and ran over to the bed.

"Oh Jessica... this is absolutely wonderful", he gasped, with amazed delight.

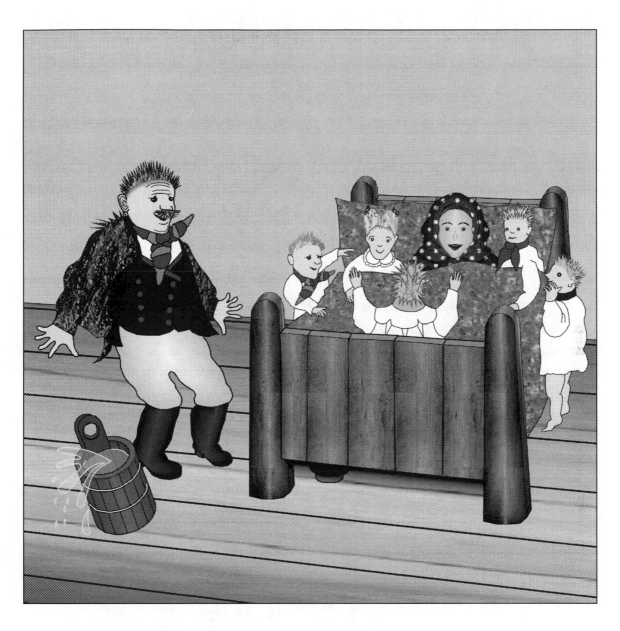

All squirming to snuggle up to their mother

"Yes, they are indeed a gift from heaven", said Jessica quietly, with tears of joy on her cheeks. "This is your father, children", she added... and with much squealing and squeaking, the little hedgehogs started to greet him. They tried to climb his legs and arms, and reached to stroke his face as they done to their mother.

Jasper was as pleased as can be, and gazed proudly at the babies... four boys and one girl. He turned to lie on his back, so that they would not prick themselves on his sharp spiny coat, and he picked them up one by one, laughing as they all struggled to get as close to him as they could. The little house resounded with their joy and laughter.

Jessica was now feeling much better... so she decided it was time to get up and prepare something to eat. Then Jasper suddenly remembered the snake. Immediately, he rushed out, back down towards the stream. Before long he was back, pulling the enormous snake behind him. indeed, so big was the snake, that it would not even fit into the room. The children ran around it, full of curiosity, while their mother looked reproachfully at their father. Jessica had guessed what had happened... so Jasper had to tell all about it. Six pairs of eyes gazed solemnly, and six pairs of ears listened with excitement, as he began to recount his adventure.

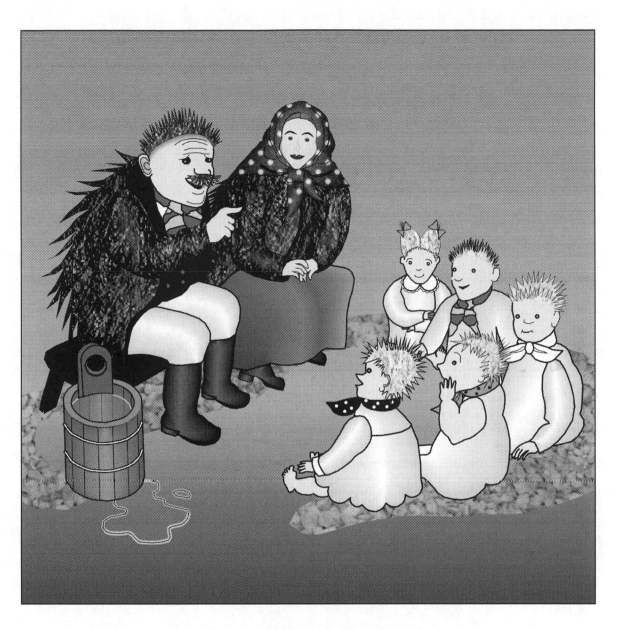

Jasper had to tell all about it

He did not forget anything -- how mother was not feeling well, and how he rushed with the bucket to get some water, and how the snake attacked him. Then he lowered his voice, and described his fear that the snake would bite him, and Mother would never get her water. He was re-living that terrible fight again, and his listeners didn't make a move or sound. Jessica too said nothing, but she was secretly proud of Jasper's bravery. When the tale was finished, they all breathed with relief at his narrow escape, and Jessica said to him: "You see, if that snake had bitten you, you would never have seen your children! "

Jessica then prepared the most delicious roast snake... and soon they all sat down to eat. And how they all enjoyed it! But meanwhile, none of them noticed that someone was watching through the window.

A grumpy old badger, who had his house nearby, was not at all happy when the hedgehogs settled in his neighbourhood. He usually took good care to avoid them... but today, he heard the noise of joy and celebration coming from the hedgehog's house, and his curiosity would not leave him in peace.

"Well, well, what have we got here?", he said to himself as he peered in through the window. "So many young rascals! This is the end of my peace and quiet!"

His curiosity would not leave him in peace

Then he noticed the tasty smell... and knew it was a snake roast. He also remembered seeing a snake from a nest in the valley, who had been searching for his companion in vain. Scowling deeply, the old badger slowly plodded home, his head lost in thoughts. He did not even notice a little mouse that crossed his path. And that was serious... the badger was preparing a plan. The hedgehogs were in danger.

Bang! The noise filled the house. One of the little hedgehogs had fallen off his chair, and the rest of the children were laughing: "Tee-hee-hee, he's rolling" And so he was... he rolled like an apple right across the floor. Then the crying burst out. Who would have thought such a little hedgehog could have such a strong voice'? He screamed so loud, it deafened everyone. This made the other children laugh even more, until the noise was so unbearable, Jessica had to block up her ears. So Jasper had to reprimand them, and immediately they had to go to bed. Being so small, they all fitted into Mother's bed. They snuggled up together and soon fell asleep.

Jessica got to work at once. She had to make five little coats, so the children would not be cold when they went out in the chilly forest air. Meanwhile, Jasper was making a new bed for them out of bark. It would be comfortable and wide, so they could all sleep well. From time to time, he peeked in to look at his sleeping hedgehogs. When returning, he met Jessica's gaze, and both of them smiled. Their happiness was complete!

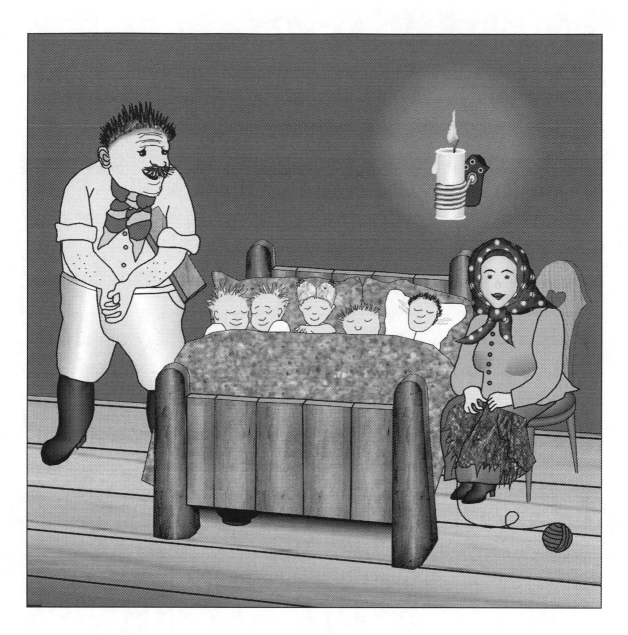

Their happiness was complete!

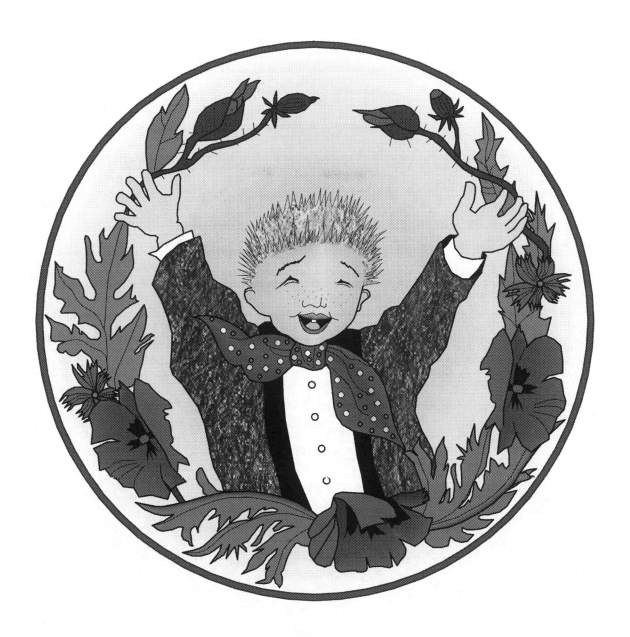

CHAPTER THREE

Joshua Prickles

CHAPTER THREE

Joshua Prickles

It was a beautiful day... everything was bathed in golden rays of sunshine, and the whole countryside was singing. In the field below the forest, even the mice felt playful, and were running around merrily. They did not notice the hungry eagle cruising high above them in the blue sky. Anyway, surely it would not notice them from that height? But the eye of the eagle is sharp, and does not miss even the smallest of the animals. It circled and circled, and then suddenly stopped -- like a stone, it fell down, straight towards the middle of the mice.

Goodness, what a panic! As if a shot had been fired, the mice all scattered to take cover in their underground homes. Except for one, a nice velvety little mouse, who ran the wrong way -- uphill towards the forest. She ran and ran, and she could almost feel the eagle's sharp claws cutting into her back. But it was only a thorny hedge that was swinging over her, and after a few more steps she was hidden in the forest. She breathed a sigh of relief at escaping from such a terrible danger, and stopped to take a rest. But the very next moment, out in front of her sprang the snake!

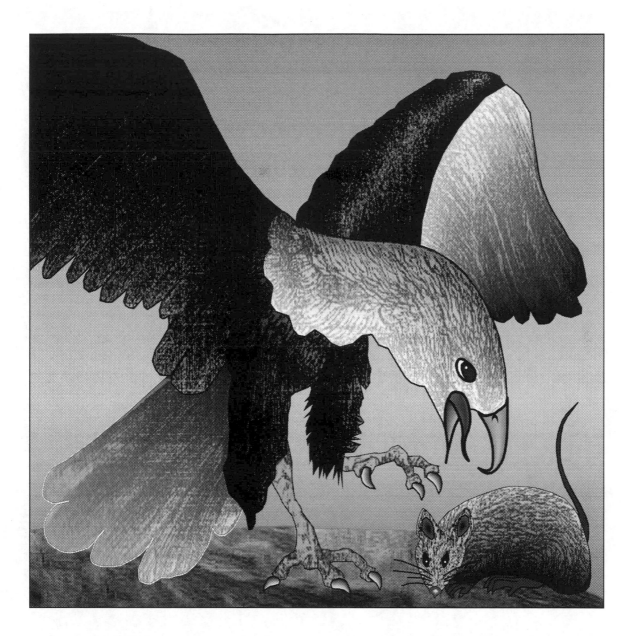

They did not notice the hungry eagle cruising high above them

"Sssss! This will be a fine delicacy", hissed the snake. The poor mouse ran desperately for cover amongst a nearby fall of rocks and stones, but the snake quickly followed. Then a deep voice snarled loudly from behind... and the snake turned round. It was the grumpy old badger, who lived near the hedgehogs' house.

"Leave the mouse alone, she is mine! " said the badger to the snake.

"Sssss, is mine!" hissed the snake, angrily lifting his head.

"She belongs to me... I saw her first", argued the grumpy old badger. But the snake did not want to give up his prey, and stood by the stones, watching the badger's every move.

"If you leave the mouse to me, I'll tell you what happened to our companion." The crafty badger was plotting to get the mouse, and get rid of the hedgehogs at the same time. The snake's eyes lit up with curiosity... finally he will find out who took his brave companion.

"What do you know about thissssss? What do you know?" he hissed, pushing his head forward, close up to the badger. Obligingly, the old badger told him everything he saw.

"Sssssssss!" As the badger told his tale, the snake's eyes flashed green with anger and the desire for revenge. "Very well... the mouse is yours, but I am going to have all those hedgehogs." With that, the snake disappeared into the tall grass.

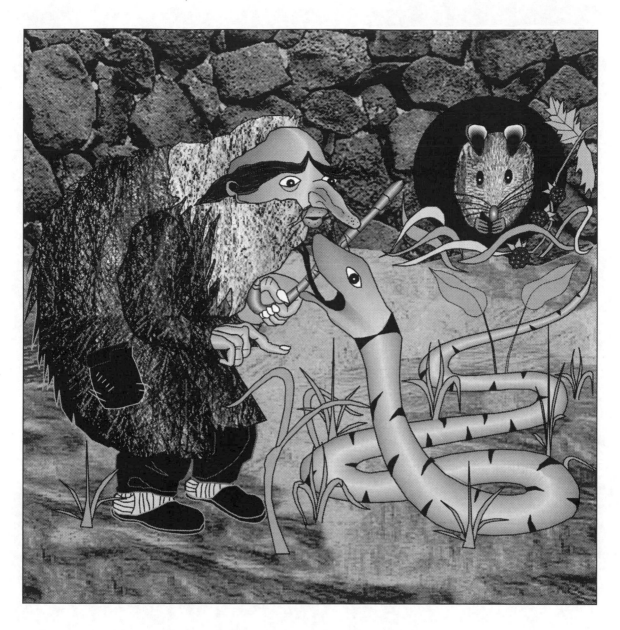

Leave the mouse alone, she is mine!

The old badger threw himself eagerly onto the stones, but he searched and searched in vain, turning over the stones in exasperation -- for the mouse had long since gone.

Meanwhile, the five little hedgehogs were happily playing in their new bed, and having a high old time. They were kicking and scuffling so much that moss from the pillows was flying everywhere. Then Jessica laid the table with a delicious breakfast of whipped strawberries in acorn cups. Jasper was busily carving a wooden stick... he had made five of them, one for each of the children. Each was beautifully carved, with a smooth curved top, and a name engraved on it.

And how delighted they all were, when after breakfast he gave out all the sticks. The little girl's one had "J e s s i c a" on it, as she was named after their mother. The biggest of the boys was called Jasper, after their father. The third stick was given to Rufus, the most handsome of all the boys. The fourth one was for little Billy, who was chubby and mischievous, and the last one was for Joshua.

Joshua Prickles was the smallest of them all... but he was also the quickest and the cleverest. He had a curious nose, and lovely black twinkling eyes. His coat had shiny pin-sharp prickles, a strong defence against any enemies... and underneath it beat the bravest, kindest heart you could wish for. No wonder then, that despite his size, Joshua soon emerged as the natural leader of all the children.

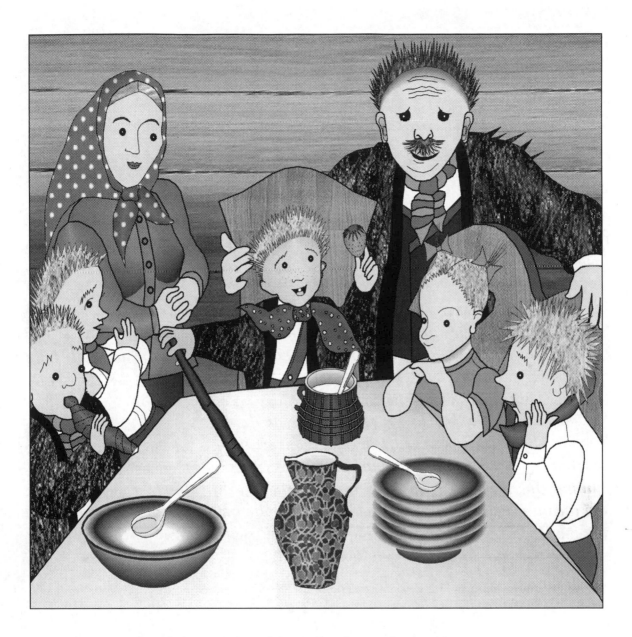

A delicious breakfast of whipped strawberries

Little Joshua could sing as well, and very loudly! You could hear him for miles around when he started his favourite song:

"Joshua Prickles is my name,
To guard my kin shall be my aim.
With needles sharp upon my back,
I'll foil the foe that may attack."

And how proudly he would march with his stick and his shiny coat! Father Jasper was taking all the boys on an expedition -- he had promised to take them further than ever before, right down to the lake, to see the concert of the frogs.

"Oh gosh, the frogs' concert... that's really going to be something!" they exclaimed. With their sticks hitting the hard ground, they marched almost like soldiers, and the journey was passing very quickly. Or at least it did until Billy started to cry... his feet were aching so much, they had to stop and rest. So Father Jasper began telling them a story:

"When I was about your age, I went one evening for a walk with my mother and father. As we walked through the woods, we suddenly noticed a red light shining. One moment it was shining very brightly, then it would fade slightly... and then it would flicker bright again. We stopped and stared with fear. "I will go and have a look what it is," said my father, "and you sit down here and wait for me!" But I begged him to take me along.

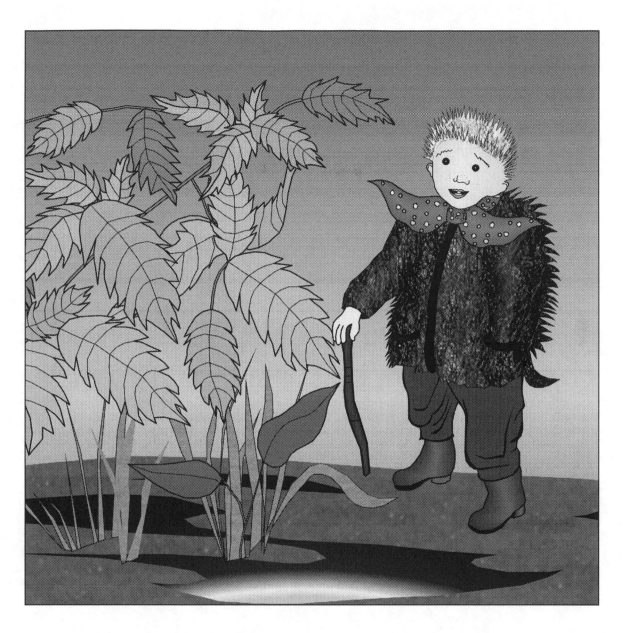

How proudly he would march with his stick

"Well, if you are such a hero, you may come! But you must be absolutely quiet! Who knows what this strange thing might be?" And so we went together.

In a little while, we could hear crackling noises and voices. "These are humans," whispered my father. I had heard about people many times before, but this was the first time I had seen them up close. And I did not like them very much. They sat around the fire, which was shining bright, and their eyes glittered like embers. And then one of them, who had a black beard like a raven, stood up and said: "Hey boys, we need some tasty meat to go with these potatoes!" The others all started to laugh, because they knew there were no deer or game in this part of the forest. "That is true," he said, "but the forest is full of hedgehogs. Take your sticks and let's go and get some."

You can imagine how we both felt. At this point, the wind blew in, and dense smoke covered our eyes. We could not see anything, and when it cleared, we could only see the bearded man, sitting by the tire. The rest of them had scattered through the woods.'

Father Jasper got up and looked to see if the boys had fallen asleep. But no! They sat there motionless, their eyes glued to father's lips, anxious not to miss a single word. They forgot all about the frogs' concert and were living in their minds their father's adventure.

Then impatient Joshua asked: "So what happened next, when the men had scattered through the woods?"

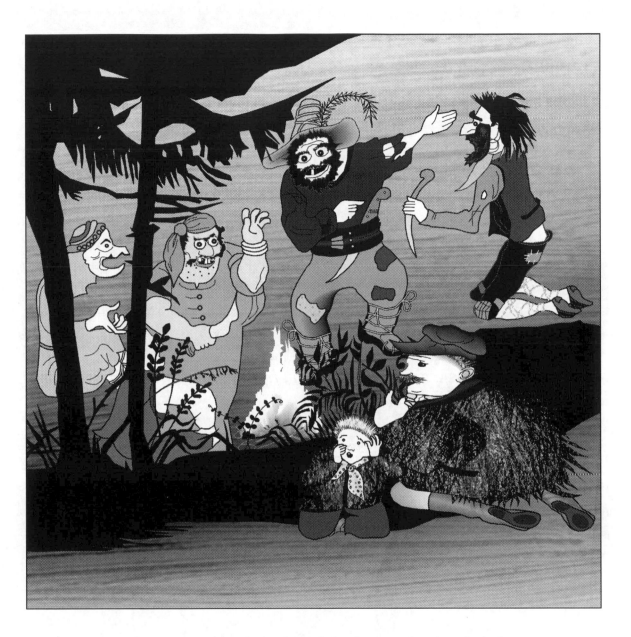

They sat around the fire, which was shining bright

'We got very scared. Not so much for ourselves, but rather for mother, who was waiting for us in the wood. We rushed back immediately, and, thank goodness, we found her safe and well. She was peacefully sleeping, and knew nothing about the danger all around. Next day we learned that these were not very nice people... many of our friends had disappeared that night.'

Father Jasper paused for a while, and the little hedgehogs also seemed to have nothing to say. They were all thinking about these bad people.

Meanwhile, the sky had blossomed with myriad stars, and above the forest shone a bright full moon. It was time to start another march. Along the path, they saw a crowd of small flying lights, and father told them: "These are glow worms, you must never hurt them. They are good, and they never hurt anyone either."

"Krak--krak!" echoed in front of them... and again "krak--krak". Father said that these were the frogs, and soon they would reach the lake. Joshua started to run forward and the rest followed him.

They quickly reached the dense tall reeds that grew by the lake. The young hedgehogs had never seen anything like this before, and were delighted... they played hide and seek, calling to each other, and dodging between the tall stalks, which rattled as they ran. And how they loved to tiptoe through the soft mud! They poked their sticks into it, and laughed when bubbles burst out of the little holes they made.

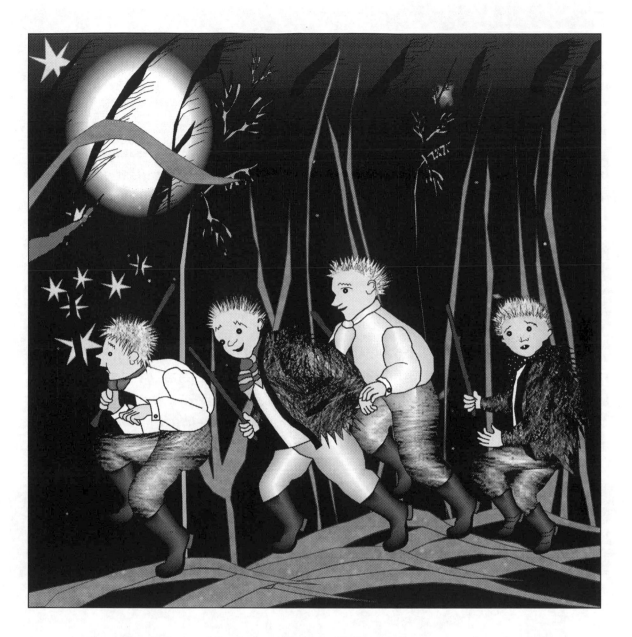

They quickly reached the dense tall reeds that grew by the lake

Suddenly, there was a terrible scream. It was poor Billy, who had fallen into the water up to his waist. Father followed the scream as quick as he could -- but it was Joshua who held his stick out to Billy, and pulled him out of the water, and Joshua became the hero of the hour.

After this, the little hedgehogs were not allowed to run around on their own, but had to stick close to their father. He found some dried reeds, pulled down by the wind, which made a fine bench for them all to sit upon.

How brightly the moon was shining! There was a big flat stone sticking out of the water, and it shone like a white sheet. Then, again they heard "krak.-krak"... from left, from right, and from all around. But there was nobody to be seen anywhere.

Then suddenly, ripples burst out on the water next to the stone, and upon the stone a frog appeared. Joshua's eyes almost popped out with astonishment. And indeed this was a sight to behold... the frog was wearing a shiny green tail-coat, and stood very importantly. He had one foot proudly stretched forward, with one hand on his hip, an in the other hand he held a small white stick.

"This is the Conductor," said father, "watch carefully how he is going to wave at the singers with his stick."

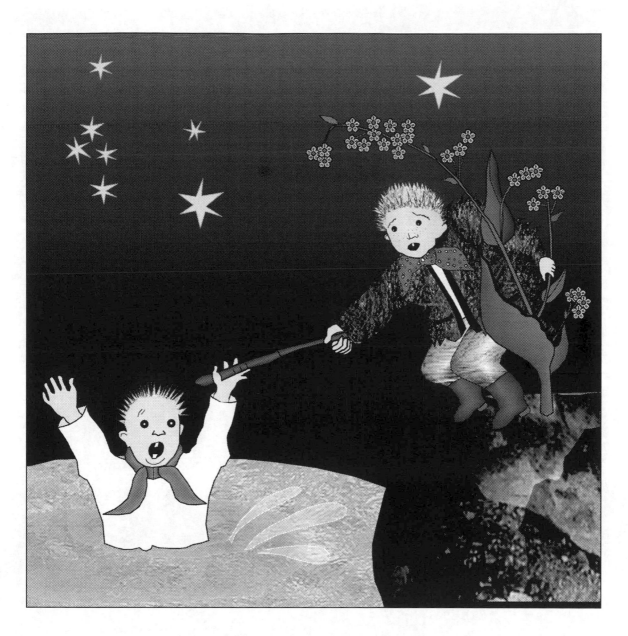

It was Joshua who held his stick out to Billy

The conductor looked around a few times, and then called out "krak-krak-krak". Then it all started... the surface of the pond suddenly became full of ripples as the frogs all leapt out. There were so many of them that the stone wasn't. big enough to accommodate them, and many of them stayed on the shore. Around the conductor were only the chosen few.

There were frogs everywhere, small ones and big ones, and the hedgehogs couldn't stop looking at them all. But Joshua was watching only one place, the stone with the conductor. Then the tails of his coat suddenly jumped up, as he lifted his arms... and the quiet night air was filled with the sound of the frogs singing:

> "Kark, kark... kraky, kraky,
> Kark, kark,... krak, krak."

And then the conductor pointed at one of the singers, who started a solo:

> "The Water Sprite sits by the willow,
> Looking at the moon."

And then all together:

> "Kark, kark... kraky, kraky,
> Kark, kark... krak, krak."

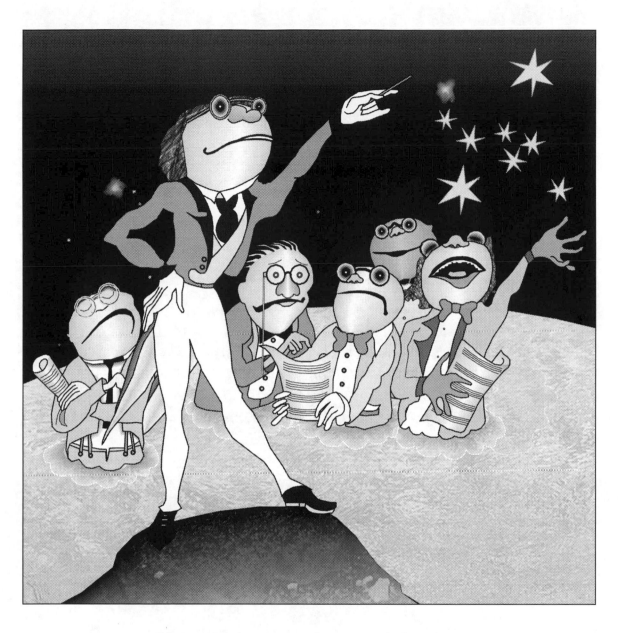

The conductor pointed at one of the singers

The hedgehogs in the reeds also started to sing along, "kraky, kraky", and Joshua waved his stick just like the conductor. Father Jasper just sat and smiled. The singers continued:

"The game-keeper walks by the willow,
But who is sitting there'?
He spies a green coat in the shadow,
Kraky, kraky, krak.

The Water Sprite then he does recognise,
And shoots him with his gun.
A puff of smoke swirls before his eyes,
Kraky, kraky, krak."

And the little hedgehogs again went "kraky, kraky, krak". They were swinging on the reeds, and as they were also laughing so much, it's a wonder they did not fall into water. Joshua was imitating the conductor so accurately, that Father Jasper too almost choked himself with laughter. Then the conductor waved his stick again, and the singer started once more:

"The smoke has vanished in the air,
But still the Sprite is sitting there.
The keeper is scared and runs away,
The Water Sprite laughing all the day."

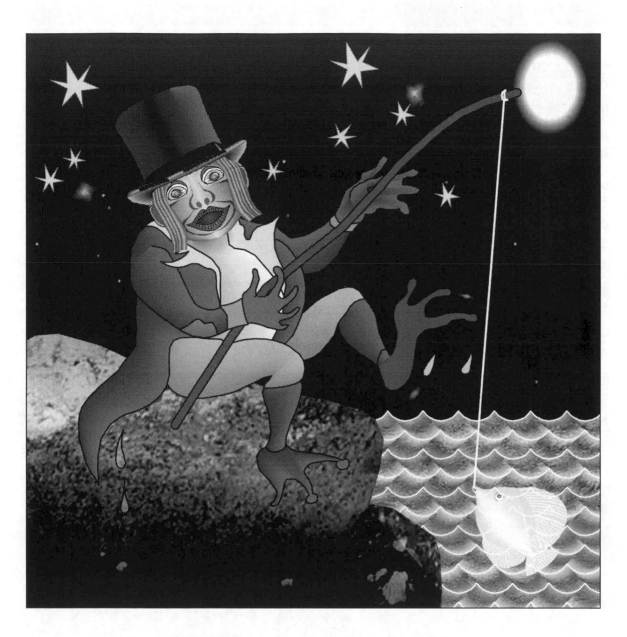

The Water Sprite laughing all the day

The chorus of the frogs thundered and echoed all over the lake: "Kark, kark --kraky, kraky"... but they did not finish. Suddenly, a dark shape appeared, and before anyone could see what was happening, the conductor had disappeared. Only his shiny stick remained, where he had dropped it. The hedgehogs became very frightened, and Joshua was in tears over the fate of the conductor... a passing owl had taken him for his dinner.

But what would the singers do without their conductor? With great leaps and jumps, they were leaving the concert hall on the stone, and returning to their homes by the lake. Water was splashing on all sides, and the boys had no time to follow the strange departure of the frogs' orchestra. It did not take long, and the lake soon fell silent.

When father and the boys were returning home, Joshua was unusually quiet, and paused to take a rest. Sadly he was remembering the abandoned stone, as if he could still see Mister Frog waving his hands, with the tails of his coat flying about. But most of all, he remembered how he was fencing with his stick... that was what Joshua liked best.

And Joshua decided to himself that he will never eat snake roast or beetles... only the fruits of the forest. As he sat there lost in his thoughts, he did not even notice that father and the other boys were long since gone.

THE END

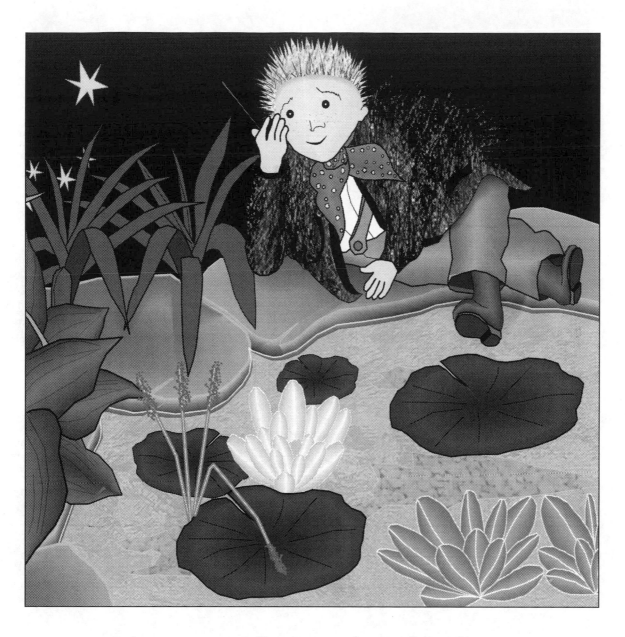

Joshua was unusually quiet, and paused to take a rest